FANNY HILL'S COOK BOOK

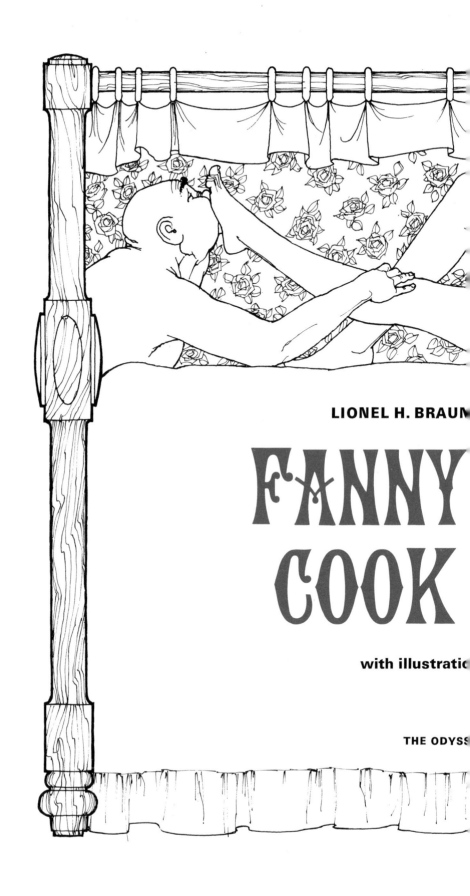

LIONEL H. BRAUN

FANNY
COOK

with illustratio

THE ODYSS

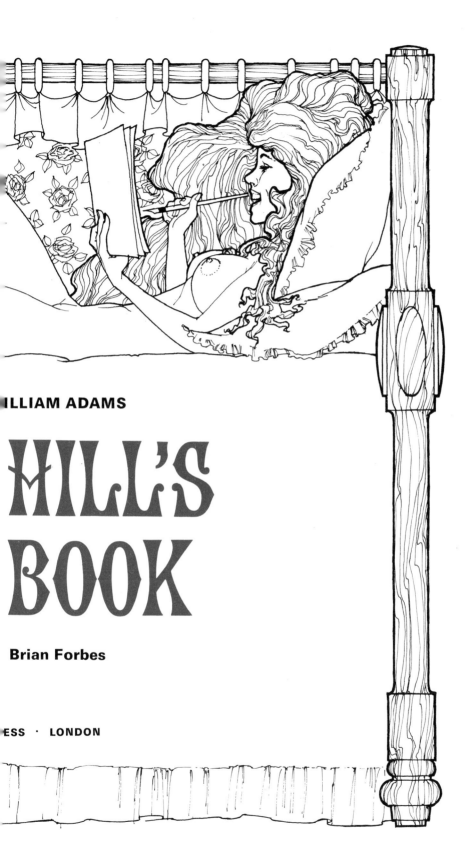

ILLIAM ADAMS

HILL'S
BOOK

Brian Forbes

ESS · LONDON

First published September 1970
Second impression February 1971
Third impression January 1972

© Odyssey Press Ltd.
2 Bramber Road, London W14 9PB
A division of Penthouse International Ltd.

SBN 850 95100 3

Printed in Great Britain by Flarepath Printers Ltd.,
Watling Street, Colney Street,
St. Albans, Hertfordshire
and bound by Wm. Brendon & Son Ltd.,
Tiptree, Essex

DEDICATED

To all sons of
Adam who've gone
astray, and all
daughters of Eve
who would like to.
To all who've
reached the age of
reason, and reasoned
'Why not!'
and all who've reached
the age of consent
and just loved to.

Contents

PREFACE

Which came first, the chicken or her egg man? And what did Adam do before Eve came? If he had things in hand, so to speak.

In fact, one night in the Garden, a voice said, 'Adam, a little do-it-yourselfing is part of the game. But you're doing it just a mite too handily'.

'But', protested Adam, 'things are awfully hard'.

'I know', said the voice. 'But there are such things as rules, you know'.

'You're going to give me hell?' Adam trembled.

'Something like that; we're going to give you Eve'.

So Adam lost a rib and gained a free hand again. And as in the way of all mortal flesh, when things went hard for Adam it was Eve who was really up against it. Then the eviction notice went up as Adam went down. For the fall of man was surely the spring in Eve. In any case, the two of them gave us an appetite for forbidden fruit that's never, thank heaven, been dulled – for such eating is paradise now!

Here then are a great girl's recipes for twosomes, threesomes and moresomes, for all well-matched and mixed sexes at their table of delight. And this is perhaps the very first cook book that is also a call to arms – a book to offer you food that is presented to sustain the libido, tickle the fancy and not only entertain pallet and palate, but one to give a little prick and a stir here and there to the minds of a man and woman in love.

enter

FANNY HILL

– a chef d'amour du culinaire, a woman of many parts who has used them all well. Not ill used but well used, nor too used for the user to find well worth using again. Surely anything else is contrary to man's better nature and woman's greatest need. So, to follow the thoughts and recipes in this book is like infringing upon the bed of a lusty man; trespassers will be violated. But with pleasure aforethought and satisfaction guaranteed, the carefully tested selections in this cook book will answer any mood, and make it more so (with enlightenment!), like a candle in an old maid's hand.

So, one touch of Venus, a little glass of wine, and a meal to commemorate the lasting moment's fancy . . . Such fine cuisine is the sport of kings each queen must love. Bon appetit! And a long good-night with *Fanny Hill*.

1

WHORES d'OEUVRES
and snacks

NINA'S NOTCHKA

 N CERTAIN DAYS,

you might get odds that even a **White Russian** thinks a piece-pack is a red-flag waver. In any event, co-existence can be firmly established by filling a hot void with ovum of a noble kind.

$\frac{1}{2}$ oz. yeast
1 cup warm milk
1 cup fine white flour
1 cup buckwheat flour
pinch salt
3 egg yolks
2 beaten egg whites
1$\frac{1}{4}$ cups whipped cream
2 tblsps. caviar for each blini
1 tblsp. butter for each blini
1 tblsp. sour cream for each blini

Dilute yeast in warm milk. Mix, do not let curdle, pass through strainer. Sieve in white flour and buckwheat flour and mix with pinch of salt. Put in a bowl and add the liquid yeast and warm milk. Mix in the 3 egg yolks. The paste should have the *light* consistency of pancake batter. Leave to rise in warm place for 2 hours.

Add 2 beaten egg whites and the 1$\frac{1}{4}$-cups of whipped cream. Cover and let rise for 20 minutes.

Serve piping hot with caviar, butter and sour cream.

IF

you're endearingly endowed with a long hard one, covered with delectable warts, stick it where it'll do the most good. This one was meant to be sheathed deep in a creamy spread. So take a fresh breadstick covered with sesame seeds and treat it tenderly as follows:

1 lb. cream cheese
½ lb. sweet butter
1½ tsps. Dijon mustard
3 tblsps. chopped chives
3 tblsps. mashed capers
1 tblsp. paprika
2 tblsps. anchovy paste
1 oz. dry Vermouth

Blend with electric mixer or wooden mixing spoon, and spoon into small crocks or handle-less cups. Chill until half an hour before serving as dip with sesame seeded breadsticks.

DILDOUGHS
WITH
WARTS
IN
HOT
LIPS

CHEESED BALLS

Here's a Swiss bell-ringer to make any miss yodel with delight. It takes a lot of balls! But if you dip your thick mixture into some hot fat it's well worth the effort. Remove your balls, however, as soon as they begin to puff up and turn brown from the heat. Drain your balls and pop them in the mouth of a deserving guest.

Mix 4 ozs. grated Swiss cheese with 2 egg whites, lightly beaten.

Make a thick mixture and shape it into small balls. Roll your balls in fine bread crumbs. Drop them into hot deep fat or oil.

Remove balls when they puff and begin to brown. Drain on absorbent paper.

BLACK TRIANGLE
WITH HOT
LICKS

lover's geometry that proves the sum of the parts is, indeed, a great hole. This is the kind of black magic with something fishy about it, but great to cast your bait in or bite.

Remove the crust from extra-thin toast when cool. Cut it into triangular pieces, each having a two-inch base, about 4 inches long. Spread the bottom third with black caviar, and decorate with a red slit of red pimento. Spread the remaining two-thirds with *Hot Licks* made as follows.

Mix thoroughly:

$\frac{3}{4}$ lb. soft butter
3 tblsps. finely chopped shallots
1 garlic clove mashed to paste
4 tblsps. finely minced parsley
1$\frac{1}{2}$ tsps. salt
$\frac{3}{4}$ tsp. fresh ground pepper

Chill until ready to use.

If you keep your cool, there's a great way to treat long hard ones. And they'll treat some little twist's tongue most tartly.

3 cucumbers
2 bunches radishes
2 bunches scallions
1½ cups sour cream
1 tblsp. lemon juice
1 tblsp. vinegar
1 dash pepper
¼ cup dried chipped beef, uncooked

Slice cucumbers, radishes and scallions very thinly. Beat together the cream, lemon juice, vinegar and seasoning. Mix with vegetables and beef and keep tightly covered in refrigerator for two hours before serving.

Then find a cute little corner and whisper this as the night grows young:
Polly pickled a peck of fickle peckers, but the fickle peckers Polly picked, were meant less for picklin' than to dick.

PICKLED PECKERS

MARQUISE
d'SALADE
WITH CRAFTY EBBING
UNDRESSING

Here's how to toss a green goddess until she
comes across with delight. Dig your whisk into
her bowl! Toss her around until she's creamy!
Now draw and quarter your tomato, and give
her the meat with a vengeance!

1 lb. back-fin lump crab meat, seasoned in bowl with $\frac{1}{2}$ cup sherry
1 bunch fresh romaine, cut into strips, then quartered
3 large stalks Pasqual celery, chopped
$\frac{1}{2}$ cup watercress
2 medium tomatoes, quartered

Toss salad thoroughly with crab meat mixed in.
Serve with the following dressing:
1 cup mayonnaise
$\frac{1}{4}$ cup minced parsley
$\frac{1}{4}$ cup chopped chives
$\frac{1}{2}$ tsp. tarragon
$\frac{1}{4}$ tsp. dry mustard
$\frac{1}{2}$ tsp. garlic powder
2 tsps. anchovy paste
$\frac{1}{4}$ tsp. pepper
$\frac{1}{2}$ cup sour cream

Most women come to realize that certain eggs are a highly edible source of extractable protein. Some are more extractable than others. Among these, and most men agree, are the eggs of a clean healthy chick. Eat hearty!

BUT FIRST bring your white sauce to a head. Take 2 tablespoons each of butter and flour, ½ teaspoon salt, a few grains pepper, 1 cup milk. Get your lovely paste in something like a hot double boiler by adding the flour then salt and pepper. Stir around until you feel it thicken up. Add some of your milk until it's also stirred around. Then get the creamy whole hot enough to be thick again.

Get your eggs hot and hard in the containers they come in (the shells), by boiling for seven minutes. Crack your balls gently until the shells come off. Now discard the ends of the eggs, which are more tasteless, until you have firm round balls. Now pour it all into your favourite hot dish. Top with grated parmesan and heat under broiler until the head is limply pliant but a little browned off.

Keep in mind that it's always best to use six large size eggs for your balls, and don't come out with less than 2 cups of creamy sauce.

CLIMAX

PUDDING

HIAWATHA'S
TOTEM
POLE

How do you poke-a-hantus?

Well, you take a hot mealy cob, and, if you make out, you're sure to get in some indian's puddin'.

2 cups milk
2 tblsps. cornmeal
½ cup molassses
2 tblsps. sugar
1 tsp. ginger
1 cup cooked chopped bacon
⅓ cup pimentoes
¼ tsp. salt
3 egg yolks slightly beaten

Scald milk in double boiler, adding cornmeal gradually. Cook 20 minutes over boiling water. Then add molasses, sugar, ginger and salt, bacon and pimentoes. Pour a little of the mixture over slightly beaten egg yolks, return to double boiler and cook a few minutes longer.

Serve as side dish with roast lamb or pork, or as snack with fresh fruit.

The next time you want to wag a little tail and put something long and hot in an oven, do it dog fashion. For certain pedigreed bitches not only love to lick the hand that breeds them, but will also chew the bone you throw to them. But don't dog it, vice is also for the versa. When man bites dog that's puppy love, because man's best friend is a bitch in heat.

So go to your favourite neighbourhood dog house and pick up some plump bitches to bite on. Also pick up a pack of dog blankets, sharp Cheddar cheese and a jar of chives. Take them back to your kennel and lay them like this.

3 hot dogs
$\frac{1}{4}$ lb. sharp Cheddar cheese
2 hot dog rolls
2 tsps. finely cut chives

Spread the bottom blanket out flat and lay three bitches upon it. Make a slit in each bitch and fill her slit with your cheese until each crack is uptight. Then put a smooth thick sheet of cheese over all three. Sprinkle with chive. Cover with another dog blanket so that you now have all three bitches snuggled up in a loving sandwich.

Stick it in the oven. Put the heat to them for 5 minutes at 375°F. Now you've really got some knocked-up wurst. So take it out, when the splendid creaminess is beginning to ooze through the blanket and the top blanket's beginning to brown. Then go down, Moses! Bare your teeth and dive in. O, you salty dog.

HOT BITCH IN A BLANKET

SAUCES

(Ah!)
FONG'S GOO

Ah Fong's favourite sing-song girl, Tai Won On, wears her old-fashioneds with the slit above the thigh. This keeps Fong very cleaver-minded, and gives her a certain yen. Yet as she often says, 'It's a fortunate cookie who can bank on things to come'. But here's some sauce for goosing up every gander's shortest ribs.

2 cups cooked purple-meat plums,
 finely slivered or ground
1 cup red apple sauce
1 tsp. garlic powder
1 tblsp. tomato paste
1 tblsp. sugar
1 tsp. salt
1 tsp. white pepper

Mix all ingredients thoroughly until evenly blended. Serve at room temperature with barbecued spare ribs, fowl or meat.

DEVIL'S DRIP

Here's an infernal way to pour it to your duck, or give your chicken a liquid warmth she'll love.

Mash 2 duck or chicken livers to paste, and mix with 2 tsps. finely chopped parsley, 2 tsps. grated lemon peel, 2 tsps. chopped shallots.

Add all the juices from the roasting pan, 1 cup good red wine, $\frac{1}{2}$ tsp. salt, 2 tsps. mild French mustard, 2 tsps. lemon juice. Stir and heat. Serve with fowl.

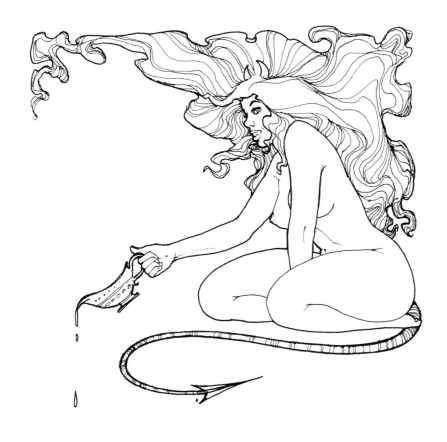

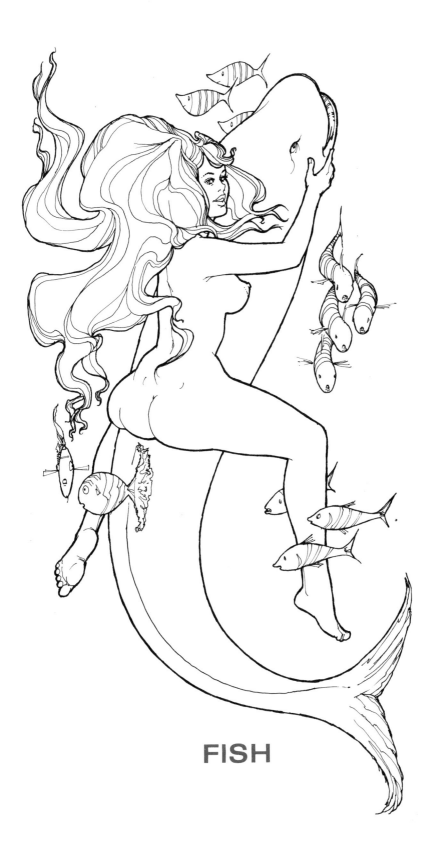

FISH

VENUSBURGERS

Under the apron of even the crabbiest females lies the means for a great laying-in. The very nicest crabs will never pinch if you get them hot enough. So if you've an itch for a most pleasant parasite, don't settle for anything small. Imperial crabs should never be scratched.

1 lb. fresh back-fin lump crabmeat,
(plus $\frac{1}{4}$ lb. crabmeat for sauce below)
3 egg yolks, beaten lightly
2 tblsps. finely chopped parsley
$\frac{1}{2}$ tsp. salt
$\frac{1}{2}$ tsp. black pepper
$\frac{1}{2}$ tsp. cayenne pepper
$\frac{1}{2}$ cup good sherry
$\frac{1}{2}$ cup cream
1 tsp. dry mustard

Blend thoroughly in mixing bowl with spoon. Put in individual crab shells and bake in moderate oven until just beginning to brown. Pour on the following sauce and serve: In hot fat melt $\frac{1}{2}$ cup hashed onion, $\frac{1}{2}$ tomato, pounded ginger, thyme, 2 garlic cloves and the $\frac{1}{4}$-lb. crab meat.

Moisten the mixture with 1 cup chicken broth. Simmer gently for about 2 hours. Then pass through a fine sieve to obtain a thick sauce. Put this sauce in a casserole with a little fat, a tsp. saffron and 1 tblsp. pimento. Mix and heat a few minutes. Pour over the baked crabs and serve.

WANG-WANG BLUES

This is a hot blues number for trumpeting about!
And yet, if you *are* going to blow up a storm, it
had better be one with a little Far Out Eastern
influence, for this is a Chinese classic with all
the subtle fireworks loved by Western gourmets.

A 3 lb. Blue fish or Sea Bass, cleaned, but with
 head and tail intact
4 tblsps. butter
4 tblsps. soy sauce
1 bunch fresh scallions, chopped
½ cup Chinese Black Beans, mashed
1 tsp. fresh ginger
1 tsp. salt
½ tsp. pepper
½ cup water

Use a steamer or a small rack or colander in a
covered kettle. Grease rack, put whole fish on it,
salt and pepper. Add boiling water to come
just below rack, not touching fish. Bring to
boil, reduce heat and steam for 25 minutes. Lift
out rack and remove fish.
While fish is steaming, put 1 tblsp. oil in a skil-
let. Add butter, soy sauce, scallions, beans,
ginger, water, and stir all ingredients until
heated. Cover with tight-fitting lid and cook
over low heat until scallions are just barely
tender.
Pour over fish on large serving platter. Let
stand 2 minutes before eating.

WHEN IT CAME to falsified credentials, medieval gay blades wore padded dickered-up deceivers in the crotch of their tight pants. However, if things aren't always what they seem, remember that nowadays women get back their own in a game of tit-for-tattle tail.

1½ lbs. salt codfish
4 peeled potatoes
6 tblsps. wine vinegar
2 egg yolks
7 tblsps. butter
juice of 1 lemon
4 tblsps. heavy cream
½ tsp. powdered ginger

Here's how to poach on some gamey giggle-bait. Call up your favourite fishwife and invite her over for a little angling. But before you throw the hook in, tell her to bring over her saucy pot. Stick your cod in cold water until it gets soft for 3 or 4 hours. Then simmer down and turn off the heat and drain your cod again, reserving the liquid.

Repeat this poaching procedure until your codpiece is limp and tender. Serve her your cod with this thick creamy sauce:

In saucepan bring wine vinegar to boil and let stand until lukewarm. Stir in egg yolks, set pan over very low flame and add, little by little, the butter, beating your sauce until it thickens in her pot, also adding the lemon juice, cream and ginger.

In the reserved liquid cook the potatoes until tender and arrange around the cod. Pour sauce on cod and service her immediately.

CODPIECES

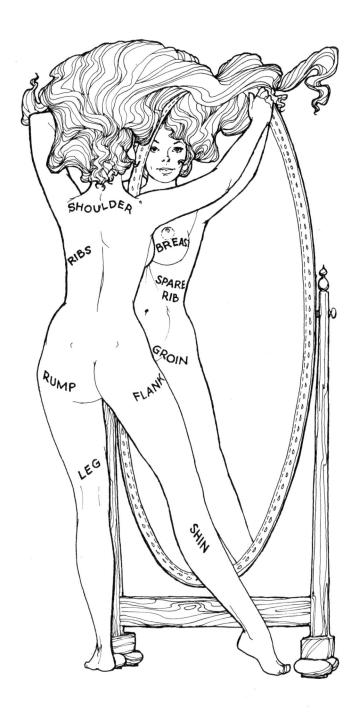

SHOULDER

RIBS

BREAST

SPARE RIB

GROIN

RUMP

FLANK

LEG

SHIN

MEAT DISHES

Any good bareback rider

knows that the most popular favourite doesn't always come first. For the most interesting races are won flat-out, and end in dead heats. So pick your running mate, get in the saddle and place your best bet forward. The odds might get you even because, as a wise mare will tell you, this is one race track where you end

in the winner's circle every time you're entered.

Following the appetizer with the entrée is like following a mini down the garden path. You should aim high, and take the maximum pleasure without stuffing beyond the point of no return. The ideal dish leaves you satisfied but ready for an encore. For as the Texas rancher said to the chorus girl, 'That's the kind of spread I like!'

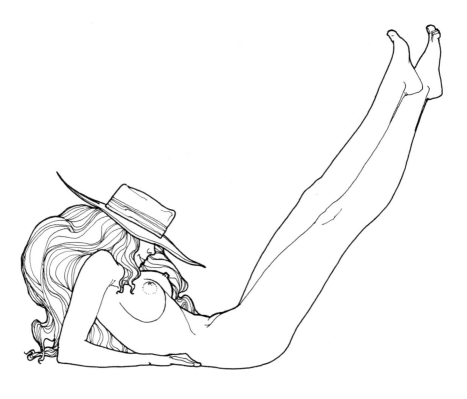

DOWN
UNDER

Insert mushrooms and oysters in pocket of steak. Season with garlic salt over all of both surfaces. Broil in hottest part of oven until cooked to desired doneness. Salt and pepper to taste.

$2\frac{1}{2}$ inch thick shell steak, widest cut of porter-house. Have butcher cut a deep pocket in centre of steak.
$\frac{1}{2}$ cup mushrooms sautéed in butter then drained
3 large or 6 very small fresh oysters
Garlic salt, regular salt, pepper

Men from Australia and Lapland have a common eating ground. And when men get hungry in Aberdeenshire on the Scottish moors, they beat around the bush, eat the bird and then shoot a full load. A dropout is bored of education, but even every tyro knows you kneel down and look at the lay when you get near the cup. All of this proves that the greatest human virtues are victories shared in bed.

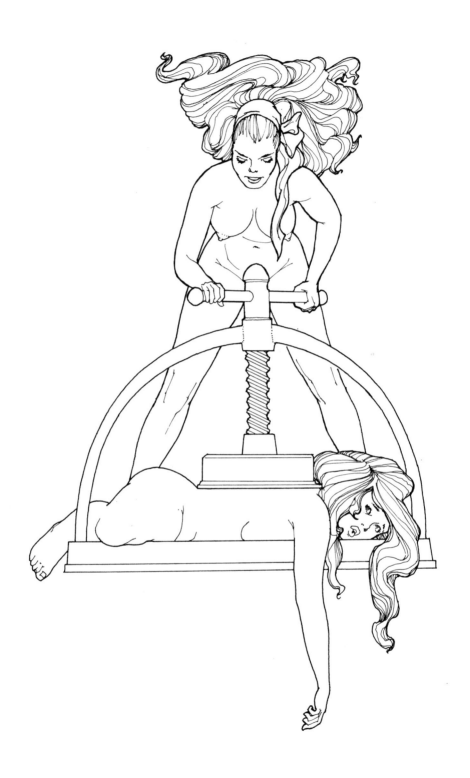

SUC d' MEAT

THIS IS A LEGITIMATE culinary term used by Larousse to describe juice pressed from raw meat, juice which runs from your meat, or the hot liquid your meat becomes when it's reduced to consommé. When you want to have your viand sucked for its hot juice, the following French method really comes into its own.
For 5½ quarts of consommé:

> 4 lbs. bottom round of beef
> 3 lbs. beef knuckle with bone in, bones broken
> 4 large carrots
> 3 turnips
> 1 parsnip
> 4 leeks tied in bundle
> 2 stalks celery
> 1 medium onion with 2 cloves in it
> 1 sprig thyme
> ½ bay leaf

Tie the meat with string and place in large stock pot, adding 8 quarts cold water. Bring to boil, skim off top layer of coagulated albumen. Season with 2 tblsps. salt. Add all vegetables, boiling very gently for 5 hours.

Remove surplus fat and strain stock through rinsed and wrung out cloth. Then for every six cups of consommé add the following:
1 cup pearl barley, washed in warm water
1 cup diced cooked ham

Pour barley into boiling consommé and cook without boiling for 2½ hours. Add ham and cook for 20 minutes. Serve with dish of grated Gruyère cheese.

BEAT-THE-MEAT

Now and then – if you can't afford an expensive piece – it's nice to beat your meat at home. Don't pound it too much, however, for if it gets too soft it won't be worth serving to the unexpected guest who might want to come.

1½ lbs. round steak
2 tbsps. flour
2 tbsps. steak fat, trimmed from edges
10 oz. can of tomato purée
½ cup water
½ cup red wine
1 chopped garlic clove
1 small chopped onion
1 medium red onion
1 tsp. Worcestershire sauce
½ tsp. salt
¼ tsp. pepper

Now! Get a pretty dish to pound your meat, or pound your steak with the flat edge of a plate until completely criss-crossed with delicious sadistic welts! Then shake soothing flour over each side of your meat, tenderly render meat fat in pan, brown both sides of your meat in hot sizzling fat.

Add all remaining ingredients but red onion, and simmer about three-quarters of an hour. Dice red onion and sprinkle on top of steak and sauce, simmer until tender.

RUMP
ROAST
OR BACKSIDE
ENTREE

The Greeks had a word for it, but
they backed into it. For the Good
Book tells us that even in the days
of old a lot of prime meat came to
a bad end. So get in line and take
your position!

3 lbs. rump of beef, about 6 slices ¾ inch thick, 1½ inches wide
10 slices of bacon
3 large potatoes, peeled, cut into thin slices
2 large onions, sliced
tsp. salt
tsp. pepper
½ shallot, chopped
1 small bay leaf
1 basil leaf
pinch of thyme
1½ cups consommé or meat stock
1 cup red wine

Now ask your neighbour's wife to bring over her deep round casserole. Line her large casserole with your stripped bacon. Add sliced potatoes as next layer, then a layer of sliced onions, salt and pepper, shallot, bay leaf and basil leaf.

Cover these ingredients with a layer of rump-beef slices. Add a pinch of thyme and tsp. each of salt and pepper. Add another layer of sliced potatoes, then another layer of sliced onions. Finally, cover with three more strips of bacon on top, pour consommé over all. Cover her casserole very tightly and stick it in.

Cook in moderate oven, 350°F. for about 2 hours or until your meat is tender in her casserole. Serve this backside entrée in casserole. When finished, wash out her casserole, thank her and send her home.

CASANOVA'S BUSHWHACKER

THE LESSON FOR TODAY is how to whack a bush. First a word or two, however, on the sport itself. It's all a matter of marksmanship. But it usually pays to lay down on the job, so get in the prone position. And remember that, when not on a dry run, the long tom shoots at a pinked pussy. A shotgun wedding is when a big bore shoots a loaded blank and gets a miss on fire.

Yes, the very best bushes were made to be whacked by some Jim's dandy. But it's really no fun to beat around a bush unless you're going to get in.

So take 2 pounds of your long red whacker in hand and shape it up firmly. For, no matter what your natural bent, every popular mechanic knows that a soft tool never makes a good can opener. On the mark, get ready, *fire*!

2 lbs. fresh-ground sirloin
3 large eggs
1 cup seasoned croutons or pre-mixed fowl dressing
1 large diced onion
2 tblsps. chopped parsley
1 cup red wine
1 tsp. monosodium glutamate
½ tsp. salt
1 tsp. pepper

This is really theatre-in-the-round. So throw it to the old casserole, meat first. Now kind of beat the meat by hand. Then crack your hen's fruit and dump the eggy goo on your meat. Mix it up good! Then add the croutons or dressing and all the spices and seasoning. Bake under a slow fire, basting with the red wine every 15 minutes until wine is used up. Remove when firm and just beginning to brown on top.

FELLATIO MIGNON

Indoors or outdoors you'll go wild
mouthing these bite-size loins of fillet
that you sauce to your own liking.

At last – group eating at its very best!
With everyone sitting around their own
'hot-pot' (fondue pot) dunking their
meat and extemporising on the virtues
of rare or well done, as well as the
proper sauces.

Most important is the proper fondue
pot. Be sure yours has curved sides so
your fat doesn't spatter. Caution: make
sure it is peanut oil.

HOW TO PLAY THE GAME:
Chafing dish,
Your own long-handled
poker or spear.

All participants beginning with a long poker and empty plate help each other to the raw pieces of fillet that must be bite size. Then you prick your poker into the beef and hold it in the boiling oil until you cook to your own shade of pink. Because the dive may take a minute or so your fingers and tongue will be much cooler if your spear has a wooden handle on it.

After your morsel has been heated, dunk quickly into one of the sauces and pop it whole into your mouth. A nymphomayonnaise bit followed by a Bare-nass (Bearnaise) or hot relish will make your tongue tingle.

A simple red wine, colourful sauces, a hot pot on the table, hot tongues above the table and hot pokers below the table, and a hungry group of lovers who love to eat with their hostess.

THE NAKED LUNCH

DID YOU HEAR about the elevator girl who asked, 'Do you want to go down?' and was taken up on it. Well, here's how Father Knickerbocker goes about it, when he wants to mouth a mature slice of life in the raw.

Leer! Feel it up! Dump your egg in the moist red middle! Finger in a little fishiness! Surround it with little wrinkly balls. And cry, 'I'm coming, Virginia!' – for the down south joy of it all!

MANHATTAN STYLE

1 lb. double-ground fillet of beef, *no fat*
4 egg yolks
1 jar capers
1 chopped onion
1 tin anchovy fillets
½ bunch chopped parsley
1 tsp. salt
1 tsp. pepper

Shape the raw beef into 4 flat rounds. Put on serving plate. Make a nest in the centre of each beef round and slip an egg yolk in each. Salt and pepper the raw meat. Lay two anchovies beside each egg. Surround with capers, onion and parsley. Now bend to the task! Eat the eggy nest, and cut a few cute capers of your own!

UP-TO-THE-HILT

Take a pretty plump baby and plunge it in! But first toss it around, and let it soak overnight until baby's meat is tender and juicy. To get baby ready you should start with the thigh and work your way to the small meat slowly.

5 lbs. young leg of lamb, cut into 2 inch squares
½ diced onion
1 tsp. salt
hand-milled black pepper
1 clove minced garlic
1 tsp. dried oregano
1 tsp. paprika
1 tsp. dried mustard
½ cup olive oil
1 cup red wine
½ lb. canned white onions
3 large green peppers
1 lb. small mushrooms
½ lb. bacon
¾ cup brandy

Make the marinade from all the ingredients
except for the bacon, lamb, peppers, mush-
rooms and white onions. Place lamb in large
non-metal bowl in marinade, toss it around and
soak overnight.
Jam your 12″ skewers up to the hilt like this:

2 squares of lamb
1 thin half-slice bacon
1 fresh mushroom
1 piece green pepper, first parboiled 2 minutes
1 small white onion
1 piece bacon

. . . and repeat.

Cook 10 to 15 minutes over hot coals or
under broiler. Keep the meat cubes close to-
gether when cooking. When ready to serve,
pour warmed brandy upon skewered and
cooked kebabs, and ignite.

FRENCH KISS

TONGUES LOVE to lick things. They also love to explore cunning crevices and loving cups and other tongues, like this one. So get in your licks, stick out your tongue and say, *Ahh*!

Cook smoked tongue by standard boiling procedure. Then skin and serve as follows:

Melt butter in skillet, 3 tblsps. Tsp. salt, tsp. fresh ground pepper. Add 2 tblsps. each parsley, celery and onion flakes. Stir over low flame until soft and evenly distributed.

Slice the cooked tongue in $\frac{1}{2}$-inch slices and add to skillet. Heat without boiling 5 minutes.

Add $\frac{1}{2}$ cup dry red wine, bring to boil and remove immediately.

ASSO BUCO

Here is a sturdy country mouthful from the Plains of Lombardy that is succulent, full bodied and hides its climax in the bone.
Your suggestion to the butcher is 'cut out for you' since the main ingredient is a very modest foreleg of veal. Tell him you want your bone cut crosswise with your meat and marrow still clinging to it.

6 pieces of shin of veal
flour
salt and freshly-ground black pepper
2 tblsp. olive oil
½ cup butter
1½ cups diced onions
¾ cup chicken or veal stock
1½ cups light red wine
4 tblsp. tomato purée
rind of 1 fresh lemon
saffron rice

Add ingredients and butter to your stock. Dip veal in flour and fry gently in oil. Remove and add wine and stock. Cook in oven for 20-25 minutes at 250-300°.
This Italian dish guarantees you'll never eat badly since it screams out in the Winter's sun – 'Eat me, eat me' – and as the bone exudes its fragrant jelly you'll savour every mouthful!

CHICKEN DISHES

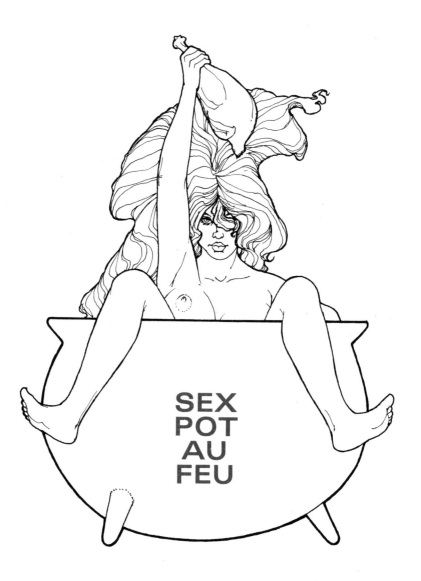

CAESAR WAS A VOYEUR because he came before he conquered. He also scampered across the Continent doing a lot of seeing in a most incontinent way, and certainly wasn't averse to watching a pot until it came to a boil.

When watching your own favourite, however, it's nice to get in the act. There's so much you can do with one like this. You can stick your chicken in her pot and stir. You can take a leek into a pot. Throw in your lean beef so your chick won't be lonely. And you might even decide to eat around the pot your chick came in.

A 4 lb. undressed chicken
3 lbs. lean beef (bottom round or shoulder)
4 leeks
6 carrots
1 peeled turnip
$\frac{1}{4}$ cup parsley
15 small white onions
8 small potatoes
1 clove stuck in small onion

Into a very large pot place meat and cover with water. Add salt and pepper. Bring to a boil over a moderate fire. From time to time a white residue will form on the surface and this should be skimmed off.

Slice leeks lengthwise and tie together with piece of string so they can be removed. Add carrots, leeks, turnip, parsnip and the small onion with the clove. Let simmer for about 2 hours over low heat. Now add chicken and continue simmering for about $1\frac{1}{2}$ hours more, or until chicken and beef are tender. About half an hour before serving add potatoes, leaving skins on. Now brown tiny white onions evenly in butter adding a tsp. of sugar to help them glaze well. Cook until soft.

Serve, including onions.

Bones were made for contention, to grow hard, serve their stiff purpose and after filling the flesh nicely to be withdrawn.

Take a plump female chick, old enough not to go to pieces while you're getting her hot. A 5 lb. roaster will do you nicely. Roast in oven (standard means of roasting 5 lb. chicken). Then let her cool out for the next encounter.

Now. Turn her on her belly and breasts, and split her where she lays! Make your own tiny hole and dip your sharp boning blade down the centre of her back. Scrape meat from her loving carcass with your blade, always working towards her plump white breasts.

Reserve her liver and the small tender meat that clings to your boner.

Spread her out on a board, skinside down. Feel her up and shape her as evenly as possible. Salt and pepper her entire body. Dice 1¾ lb. of cooked ham and 5 ounces of cooked bacon. Dice the chicken liver and 4 truffles and meat scraps, and add. Put all these ingredients in a bowl.

Add 1½ tsps. salt; ⅛ tsps. combined ginger, cinnamon and clove; a liberal dash of pepper; 1 tblsp. brandy, ¼ cup dry white wine. Stir all ingredients together for 2 minutes.

Spread 1 lb. cooked pork sausage meat over the chicken and then distribute the other mixture over it. Roll the chicken up evenly in the form of a large sausage so that the chicken skin itself forms the casing. Wrap it in a clean muslin cloth, tying the muslin firmly together at each end as well as here and there along the length of the roll . . . not too tightly as the meat will expand slightly in heating.

Put in large casserole and add 1 cup dry white wine. Simmer in moderate oven until thoroughly hot. Serve sliced with water cress or green salad.

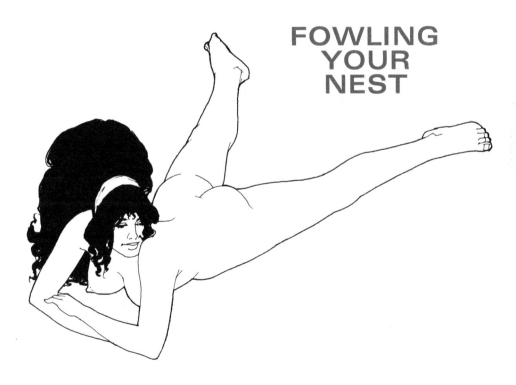

FOWLING
YOUR
NEST

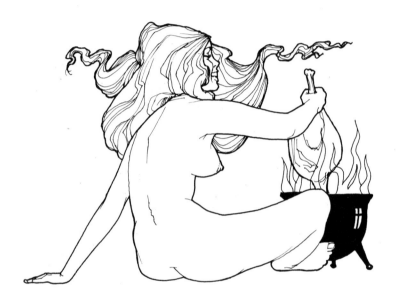

COCK-IN-THE-RED

WOMAN WAS THE FIRST home appliance that took man's heavy load upon herself. In fact, Adam was an avid do-it-yourselfer until Eve came. But then, like all couples since, when things went hard for Adam, Eve found she was really up against it. Yet Adam discovered that if he kept bearing down she would run smoothly, except for certain periods when things got especially hot and they were both in the red.

The moral of this is that the supply must rise to meet the demand.

So when you're tired of ordinarily delightful French cuisine, and if your appetite is jaded and you're too finicky to eat, dip into something quite different like this.

Cut up a little! Hack off serviceable pieces of the tender chicken you want to roast. But before you put it in the oven, prepare the common pot. In a flameproof casserole lightly brown three small onion balls with four strips of diced lean bacon.

Remove your balls and bacon from the pot. Then stick your chicken (in the fat) and brown each piece to a light golden colour.

Now leer a little and get out the hooch. Get a small liqueur glass of brandy and pour it to her! And set it aflame.

Add 3 cups red Burgundy and 1 cup stock, salt and pepper, 2 garlic cloves chopped, and a *bouquet garni*.

All chickens like to get hot slowly. So when her liquid begins to simmer, put back your balls and bacon. Add a few mushrooms to the whole. Cover her up and simmer gently, but don't stir her up, for about 45 minutes until she's feeling tender.

Remove the *bouquet garni* and cool her sauce until you can skim her fat part from the surface. Now show no mercy! Get her nicely hot again and throw the binder in . . . 2 tablespoons of your butter stick blended with something soft and white as a generous tablespoon of flour.

Always serve your hot cock-in-the-red under cover.

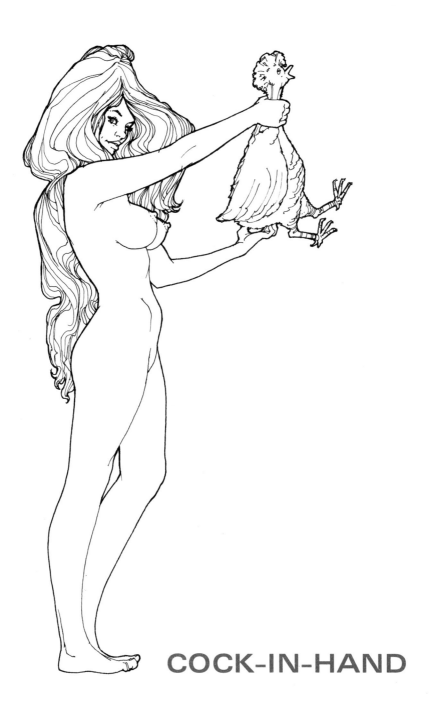

COCK-IN-HAND

THERE'S NO ACCOUNTING for tastes, but quite often the simplest new twist can give an old favourite a delightful dimension.

4 large frying-chicken breasts, cut in half
4 ozs. chopped chives
¼ lb. best quality butter
unbleached white flour

Wash the chicken breasts thoroughly and roll in flour. Fry the halves of chicken breasts in hot oil or fat until golden brown. Remove and drain on absorbent paper until completely dry of all grease.
And then, eat while hot . . . but with each bite just simply shake or spoon on a liberal sprinkling of chives over a pat-sized bite of butter, and put the chived butter upon the chicken as you eat it. It's unbelievably delicious!

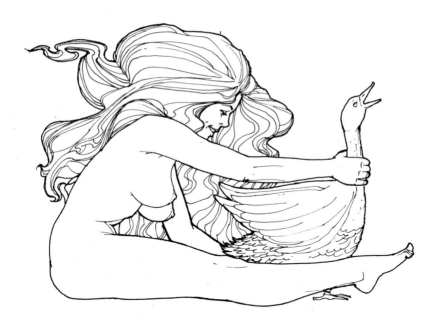

ON STUFFING . . .

GOBBLER'S GOOP

When you cuddle up to a tender young bird, love is on the wing, and elsewhere. So after your drumstick's been eaten to a fare-thee-well, you may find it nice to eat the sweet inside of your bird. For there she lays on the linen, upon her back, with her dainty crevice just waiting to be spooned. But tit-for-tat is only fair. You can only take out as much as you've put in. So first fill her up nicely, with your sausage stuffed from her end-game to her throat.

For 12 lb. goose or turkey:
2 lb. pork sausage meat
1 medium onion, chopped
1 large carrot, grated
5 cups soft bread crumbs
2 cups tart diced apples
2 cups chopped Paqual celery
½ cup cider or apple juice
½ tsp. thyme
½ tsp. marjoram
2 tblsps. chopped parsley
salt and pepper to taste

Shape sausage into thin patties, sauté with chopped onion until lightly browned, and pour off all but 8 tablespoons of fat. Break sausage up into bits; add remaining ingredients and mix thoroughly.

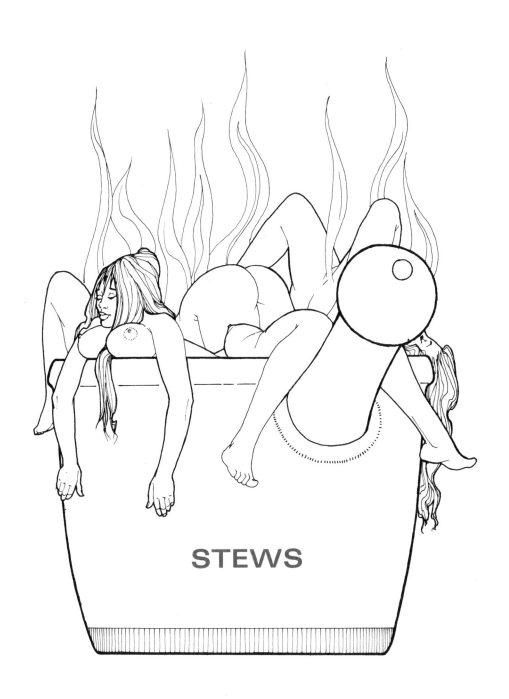

STEWS

This is really a trip for abroad. So all aboard, broadly speaking of course. But if you're going to eat your chick, you might as well use an all-over technique.

Take a young chick, and be sure she's fairly plucked. But don't crow yet, just get her browned off very lightly in a pan with hot fat. Remove her from your application of hot fat and keep her hot. Cook a cup of finely chopped onions in the fat without browning. Then cook an extra large fresh tomato, chopped. When these ingredients are tender add a heaped tablespoon of Indian curry-powder, thyme, garlic, parsley and ginger thoroughly pounded together in a mortar. Stir until completely blended. Cut up your chick as for sautéing. Add chick to other ingredients. Coat your chick with your hot thick mixture, and moisten her all over with prepared chicken stock. Just before serving add a teaspoon of curry to stock and mix into sauce.

Simmer gently for about 4 hours. Now you're off to Lapland, with your tongue in cheek!

ROUND
THE

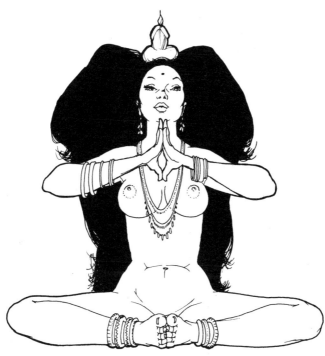

WORLD
STEW

CUBAN CRISIS

Here's a potential big blow-up most pleasant to pursue. These are wind-berries with a certain Latin air, spicy beans to put you in a jumping mood.

1 lb. red kidney beans
½ lb. pork sausage meat
1 chopped onion
1 chopped garlic clove
2 tsps. chili powder
1 bay leaf
1 tsp. salt
4 whole tomatoes cut into quarters
1 cup red wine
3 cups water

Wash beans, cover with water and soak ten hours. Drain and place in kettle with all remaining ingredients but tomatoes. Simmer gently for one hour. Add tomato quarters, and simmer three hours more or until beans are tender and sauce thick and savory. Add more water if necessary.

PASTA

CUNNILINGUINI
WITH PIETRO'S TONGUE

Here's how Pietro does cunnilinguini. First he calls up Theresa and if she feels like coming she brings over her cunnilinguini and washes it off thoroughly. Then Pietro gets her cunnilinguini hot and moist and throws in his tongue. But between the first act and last emission, there are a few agile twists to the plot . . . particularly if you want to eat with Theresa and have her, too.

1 lb. linguini
$\frac{1}{2}$ lb. cooked smoked beef tongue, cut into $\frac{1}{2}$ inch
 slices
3 eggs
1 cup grated Parmesan cheese
pinch white pepper
3 tbsps. butter
pinch salt

Bring salted water to a fast boil and add linguini, cooking for 7 minutes, *al dente*. Prepare sauce while pasta is cooking. Cut tongue into bite-sized cubes. Beat eggs adding pinch of salt and pepper.

Drain her linguini off in colander and replace in hot pot. Add your eggs, cheese and stick in your tongue and mix thoroughly with her linguini. Be certain her linguini is hot enough to allow your eggs to be gently cooked by her linguini heat. Then butter her linguini and cook entire mixture over very low flame for $1\frac{1}{2}$ minutes. Serve at once. *Remember,* when Theresa's cunnilinguini is drained and eaten, and Pietro's tongue has completely disappeared, they've both come to certain conclusions . . . *it's not how long you make it, it's how long you make it last!* Therefore, eat slowly but carry a big stick.

When Theresa wants to eat something long and
hard, she calls up Pietro and he hurries over and
sees what's cooking. Then while she's working
on it, he gets up a full head of cream. But before
he pours it on, he gives her something to chew
on. And she takes it all in. For forethought
makes the hindsight most palatable.

1 lb. fetuccini, long, broad, flat noodles
½ cup Gruyére cheese
½ cup Parmesan cheese
2 tbsps. fresh ground black pepper
4 tbsps. butter
pinch salt, pinch white pepper
½ tsp. grated nutmeg
½ cup heavy cream

Bring salted water to a fast boil and add fetuccini, cooking for 7 minutes. Drain fetuccini in collender and place in casserole, mix cream thoroughly with the cheese, 3 tbsps. melted butter, pinch salt, pinch white pepper, ½ tsp. nutmeg. Add 1 tbsp. butter on top of mixture. Place in moderate oven until hot, do not brown.

FELLATICCINI THERESA

VEGETABLES

NYMPHOMANIAC'S PRAYER

You don't need as much long green if the instrument is long and firm with a plump tip. But cream your instrument for an uptight entrée.

1 large bunch *fresh* asparagus
1 cup butter
2 tblsps. lemon juice
4 egg yolks
2 tblsps. boiling water
2 dashes salt
2 dashes pepper, black
2 dashes cayenne pepper
1 tsp. chopped fresh tarragon

Put asparagus in boiling salted water in pan, just enough water to cover. Place lid on tightly and boil until asparagus are tender but not soft. Drain all excess water and serve immediately with the following sauce:
Melt butter in small pan. In top of double-boiler, over an inch of hot but not boiling water, mix lemon juice, egg whites, tarragon, salt and pepper; cook over low heat beating constantly with wire whisk. Gradually add butter. Beat sauce until thick and creamy, adding the 2 tablespoons of boiling water a few drops at a time. Remove from heat, pour over asparagus and serve.

GOD'S
LITTLE
ACHERS

If you're going
to beat your balls,
be sure they rise again.
Then give
your baby
a lick
at your dumplin's.

6 medium potatoes
½ cup sifted flour
1 tsp. salt
2 eggs slightly beaten
½ cup fresh *uncooked* chopped spinach

Peel and cook potatoes in boiling salted water
for about 20 minutes. Let cool and put through
sieve or ricer. Allow to stand a few hours un-
covered, until completely dry. Add flour, raw
chopped spinach, eggs and salt all well-mixed.
Shape into 1 inch balls and drop into large
kettle of gently boiling water, boil uncovered
for 15 minutes.

POTATOES MASOCH

Punish yourself with calories. Ahh! The coming of cream, the whipped butter, the sinful delight of getting fat, fat, fat!

Scrub and boil potatoes whole, for 20 minutes.

Mash the potatoes and blend in the following (per pound):

2 tblsps. whipped butter
1 cup cream
½ cup consommé
1 tsp. tarragon
¼ cup parsley

Serve with roast pork or roast chicken.

FRENCHED FREUD POTATOE

Wash and peel potatoes. Cut into lengthwise slices, then into strips ¼-inch thick. Soak 2 minutes in ice-cold water, then dry. Heat to 375°F. enough hot fat to cover potatoes. Drop potatoes into hot fat and cook until tender and brown. Drain on absorbent paper. Serve immediately with the following spooned upon the potatoes:
(Per pound of potatoes):

½ cup finely-chopped chives
½ cup grated Gruyere cheese
1 tsp. salt
½ cup red wine

Mix in bowl with spoon until thoroughly blended. Serve with side garni of fresh watercress. Perfect with steak or roast beef.

DESSERTS

95

Open Sesame!
Even if your Gal Friday's
a daytime-closer
she'll always be open evenings with this one.
Some fashions never change,
and a licker's quicker
if it's got some spirit to it.

3¾ cups sifted bread flour
1¼ cups butter
1 heaping tblsp. sugar
⅔ oz. yeast
7 whole eggs
⅓ cup warm milk
6 tblsps. currants
4 tblsps. golden sultanas
1½ tsps. salt

Put the sieved flour in large wooden bowl, make a well in the middle, add salt and yeast to well, first diluting yeast with warm milk. Then add eggs and mix well to paste. Soften butter and add in small portions on top of paste. Cover and keep in warm place until paste has doubled in quantity.

Now add sugar and knead to absorb butter. Add raisins and currants and mix well.

Put paste into large well-buttered moulds filling to one-third of their height. Bake in hot oven and then cool before removing from mould.

Make syrup by adding:
1 cup rum to 3 cups of mixed sugar (2 cups) and water (1½ cups). Cook at 220°F. Stir in ⅓ cup orange syrup and a tsp. coriander. Pour over babas. Then sprinkle with straight rum and set fire.

ALI BABA AU RHUM

SATYR'S PROMISE

THE HARDER IT GETS the further it'll go! So when you cream your sweet thing, give a thought to how you pour it on.

¾ cup butter
3½ cups sifted sugar
2 tblsps. cherry purée
5 tblsps. rum

Cream butter until soft, add sugar and beat until fluffy and smooth. Add cherry purée and rum and beat smooth. Pour over dessert desired.

When you're feeling your oats, and want some-
body else to, try this. In flat-bottomed re-
frigerator dish or tray, place six rounds of
Scotch shortbread, pour 2 tblsps. blackstrap

molasses on each, beat 3 oz. anisette into 1 pint heavy whipping cream, and cover each round of shortbread with creamed mixture. Let stand in refrigerator, but do not freeze, for 1 hour. Eat with spoon.

JOCK'S STRAP

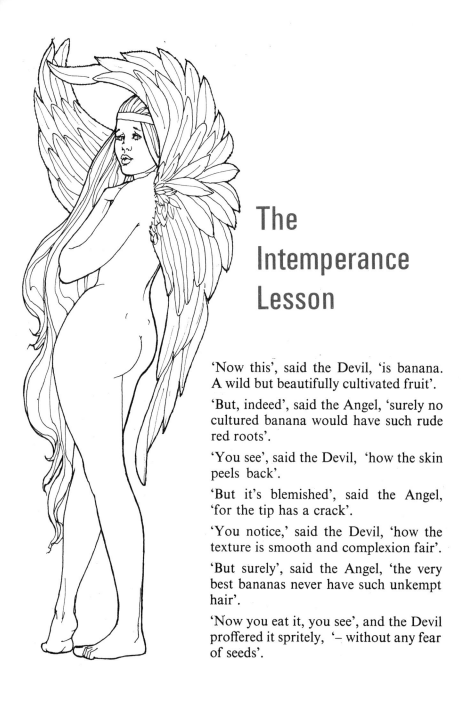

The Intemperance Lesson

'Now this', said the Devil, 'is banana. A wild but beautifully cultivated fruit'.

'But, indeed', said the Angel, 'surely no cultured banana would have such rude red roots'.

'You see', said the Devil, 'how the skin peels back'.

'But it's blemished', said the Angel, 'for the tip has a crack'.

'You notice,' said the Devil, 'how the texture is smooth and complexion fair'.

'But surely', said the Angel, 'the very best bananas never have such unkempt hair'.

'Now you eat it, you see', and the Devil proffered it spritely, '– without any fear of seeds'.

'O no!' cried the Angel, and declined it politely. 'For it's head is wet, and I'm a dry, you see'.
And that's why whoreticulture is against the law.
'Now that', said the Devil, 'is a quoit for my peg'.
'But I was told', demurred the Angel, 'that *my* name is Meg'.
'Well then,' said the Devil, 'it's a glove for my hand'.
'But I was told', said the Angel, 'that it is the promised land'.
'Indeed!' cried the Devil, 'and it's a promise I'll break!'
'O no', said the Angel, 'it's an oven for cake'.
'Ha!' said the Devil. 'Then try a sweet meat –'
'But', said the Angel, 'it's not an oven in heat'.
'Bedamned!' screamed the Devil. 'It's a cornerstone I'll lay'.
'But I must rise above it', said the Angel. 'For it's my cherry soufflé. And you shall have none. For I'm saving it up, for my husband to down, upon our wedding day'.
You shouldn't ever try to tool where angels fear to spread.

VIRGIN'S PUSH-UP

THIS VIRGIN can be made to rise to any occasion . . . if you lay her in a straight-sided container. First, butter your utensil and sprinkle it with sugar. Then warm up your virgin in moderate heat so that you penetrate to the middle of her mixture. A few minutes before withdrawal, sprinkle her with sugar and give her that satisfied glazed look by moving to the hottest part of the oven.

To make her properly creamy and toothsome depends on her size. 15 minutes will bring her to heat if she's made as follows:

$\frac{1}{2}$ cup milk
2 tblsps. sugar
1 pinch salt
2 tblsps. flour
2 tsps. vanilla
$\frac{1}{2}$ tsp. cinnamon
2 eggs
2 tsps. butter

Bring milk to boil in a saucepan, adding sugar and a pinch of salt. Add flour, previously blended with a little cold milk. Stir in vanilla and cinnamon. Cook while stirring 3 minutes.

Remove from heat and add egg yolks, and butter, and at the very end 3 stiffly beaten egg whites.

Quickly mix and fill buttered and sugared soufflé container. Smooth the soufflé's surface and cook in moderate oven. Two minutes before serving sprinkle with sugar to glaze.

Pour on the following sauce: (and serve immediately).

Add 2 cups of cherry purée to 1 lb. sugar and $\frac{1}{2}$ cup grated orange peel, all boiled in 1 quart water to crack stage (310°F). Then fold in 10 egg whites beaten stiffly.

THE
NUTCRACKER
SWEET

IF YOU FEEL like cracking your
nuts, you may as well put them
in something sweet.

$\frac{1}{2}$ lb. almonds
1 cup butter
1 cup sugar
4 ozs. bitter chocolate
$\frac{1}{2}$ cup crème de cacao

Blanch almonds and toast lightly beneath broiler, then chop
fine. Melt sugar and butter over low flame. Add the nuts and
cook to hard-crack stage at 310°F. Pour into buttered 8″ × 8″
pan and cool.
Heat chocolate over boiling water until melted. Stir in crème
de cacao when melted. Pour over nut mixture and cool until
hard. Remove from pan and crack into pieces.

The Duke and the Creamy Duchess

Glacé Duchesse de Bar! This means that the greatest dukes know that the most darling duchesses have to be creamed now and then. Especially a sweet thing like this one, who is good enough to eat with a spoon. Some people, however, say the tongue is a spoon for such confection as this Duchess of Frenched vanilla ice cream.

In any case, be good enough to lay your duchess. In a mould. Now bend over and hollow out her centre with your favourite spoon.

Then fill the duchess' sweet hollow with a stiff application of Duke, Bar-le-Duc jam. First drain the duke of some juice with your hand. When the excess trickles out you're ready to stuff it in.

Now stuff her jam with a ball, of ice cream. And repack the mould in ice. Let the duchess settle down but don't let her get frigid.

When you feel you want to get up to it, unmould the ice cream and lay the duchess on a flat smooth surface. Surround her with a wing of apricot liqueur-flavoured whipped cream decorated with a chain of candied daisies.

DAMOISELLE BRIGETTE: The Upside-Down-Tart

Stick your tongue in this hot little tart's moist delight! Damoiselle Brigette is plump and appealing and, like all little girls, filled with spice. But first you must fill her pie with something nice.

Stroke her 2″-deep round baking dish with a thick emission of your softened butter stick. Gently rub the butter down with a ¼″-layer, of granulated sugar.

Then fill Brigette with balls, of firm tart apples. Sprinkle your balls with a little more sugar, ½ teaspoon of cinnamon, and dot with butter.

But all the best tarts need a pay-off. Do it with dough. So before you come, to the really hot part, cap her off with a modest sheet of your favourite pie dough mixed with ½ teaspoon of nutmeg.

Now get her hot before the climax, in a moderate oven (375°F.) for about 30 minutes. How do you know when she's ready? Just test her by tenderly raising the sheet (of dough) and poking discreetly to see if your balls are golden and the dough is beginning to caramelize.

When she reaches this point, loosen her crust and cover the whole sweet thing with an ample serving dish. Now flip her over on her back deftly. Voila! Now she's hot and moist and sweet and ready to serve you.

Add a thick ejaculation of your cream, whipped up to a frenzy with a tablespoon of applejack or Calvados. And eat as you would be eaten, with dash and a delicate flair.

ADAM'S PACIFIER

Depending upon your most personal hang-up, the most exquisite milk containers may be round, pear-shaped, conical, pendulous, and fit to fill cups from A to D, but they must always fit the hand and the lips. They may lie low during the day, but come out at night like fondled nuts in the light of the fullest moons. Yet the grandest illusions cover a multitude of thins . . . this is the shell game where it pays to be a sucker every time.

1 pint French Vanilla ice cream
2 Bing cherries
2 ozs. Cherry Heering

Into each of two round ½-pint moulds, spoon ¼ pint of ice cream. Smooth with spoon to form white breast shape. Work straw from top centre down to bottom of mould to form a narrow channel. Fill each channel in each mould with 1 oz. Cherry Heering. Top with Bing Cherry on top of hole. It is not permissible to start on the breast until you've bent over and bitten off the nipple with your teeth.

FLAMING VIRGIN

Here's how to heat up a fruit! Not an odd one, but increasingly rare. For this virgin was made for burning. You just take the firm, red ripe symbol of what every girl is born to lose, and share. In fact, the sharing is the losing, and the loss is always gain. Alors, ignite! Give her the Hots tonight!

½ cup sugar
dash of salt
1 tblsp. cornstarch
½ cup water
1 lb. sweet or Bing cherries pitted
1 pt. black cherry or vanilla ice cream
5 tblsps. brandy
2 tblsps. Kirsch

In saucepan mix sugar, cornstarch and salt. Add pitted cherries and water. Stirring *constantly*, cook until thick.

Cool.

Serve ice cream evenly in 4 dishes. Spoon cherries over. Add brandy and Kirsch to sauce mixture in saucepan. Light with match and pour upon the cherries and ice cream.

CHOCOLATE TRIFLING
a la Miscegenationne

$\frac{1}{4}$ lb. bittersweet chocolate
3 tblsps. mild
$\frac{1}{4}$ cup sweet butter, less $\frac{1}{2}$ tsp.
1 large egg yolk
powdered cocoa

HEAT UP YOUR hot chocolate until she's creamy and then stir your milk in continuously over boiling water. Add your butter until blended by stirring. Then cool it a bit, and stir in your yolk. Now chill her until she's firm. Make your balls about half the size of small walnuts from your mixture. Roll your balls in powdered cocoa. Store in the refrigerator.

And remember, a lot of Kentucky colonels find there's nothing crumby about eating sweet Georgia crackers in bed.

What Solomon ate, surely no man should
eschew.

3 cups heavy whipping cream
1 ripe banana, sliced thin
1 lb. ripe cherries
1 medium extra ripe fresh pineapple, cut into
 thick bite-sized chunks
1 tblsp. sugar
1 cup apricot brandy liqueur

Mix fruits and brandy with sugar. Let stand in
covered bowl for 1 hour at room temperature.
Top with whipped cream and serve.

SOLOMON'S SALAD 69

DRINKS

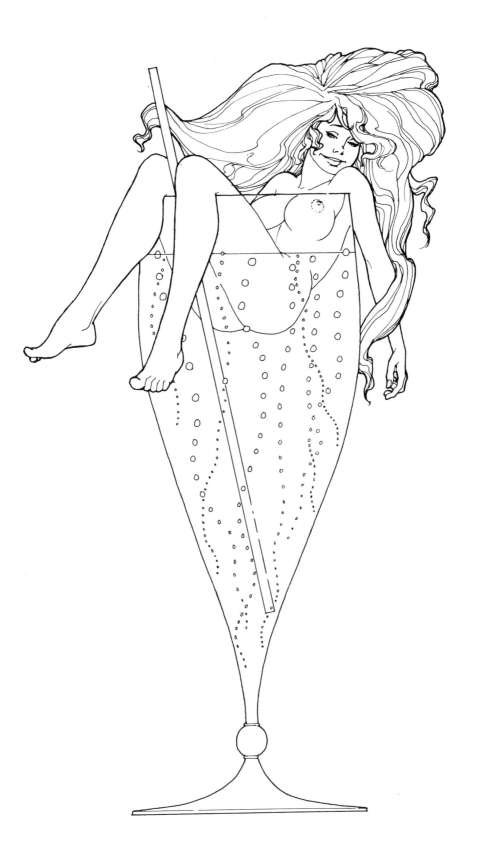

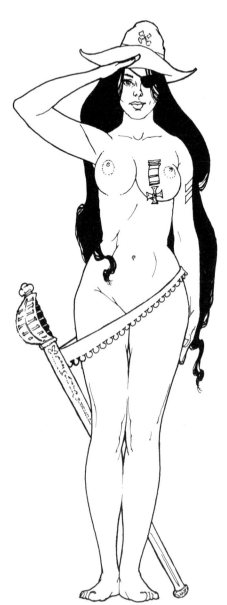

In World War II it was against the
rules for any wacky sergeant to
play with her privates in public
places . . . unless she wanted to
go off on her own.

This is a great way to put her in
orbit tonight:

2 dashes orange bitters
2 ozs. gin
1 oz. vermouth
2 ozs. cognac

Mix in shaker, pour over cracked
ice in 8 oz. glass.

THE WAC CORPORAL

FLYNN'S INNER

In the vernacular of this half cock and cook book, a slut's slit is a stuffed chicken. And giving this drink to your fat breadwinner is a wry treat, indeed. It's got so many delicious calories it'll take a high colonic and a low bend to work it off. It takes 5 minutes to make, but it's worth its wait.

Mix in blender or with beater (per serving):

 1 oz. rum
 1 oz. light rum
 2 ozs. Galliano
 $\frac{1}{2}$ pint vanilla ice cream
 $\frac{1}{2}$ cup cold milk

THE KINGSIZE ONE

Many a blown-up victim of a 100-millimetre nail has found that just because something's long and round, with a glowing red end, it doesn't have to have a filter tip. But the habit's hard to break, so you might double your pleasure by getting lit up with this one. It's a Creole Love Call that makes the delta the promised land!

6 ice cubes
2 barspoons powdered sugar
6 dashes Orange Flower Water
$\frac{2}{3}$ oz. *fresh* lemon juice
$\frac{1}{2}$ oz. *fresh* lime juice
1 oz. egg white
6 ozs. gin
$5\frac{1}{2}$ ozs. milk

Fill cocktail shaker in order with above ingredients. Shake thoroughly! Strain into two 10 oz. glasses. And it's Mardi Gras tonight!

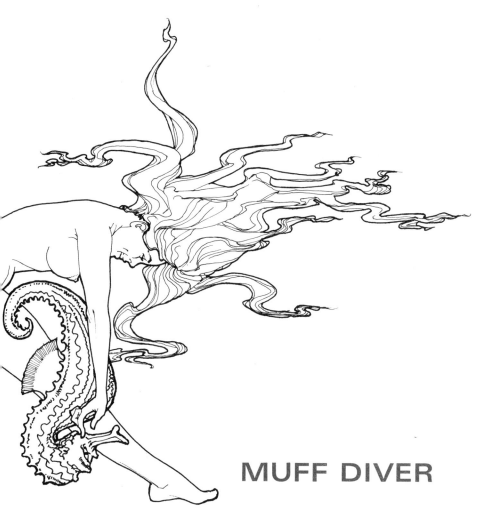

MUFF DIVER

How do you give youth its due? Well, many an old hand has tried. But if your tongue is up to it, you can often get down to cases quickly. In fact, the deeper you explore the matter the less you'll go under. And if you're really flat out you'll never get the bends. As the December groom said of his May bride, 'Money helps. Experience improves. But it isn't easy to fill the generation gap!'

2 oz. Cherry Heering, dash Triple Sec, 4 oz. Tequila.

Shake thoroughly. Take extra tall glass, collins glass or other, and fill to top with cracked ice. Pour ingredients over cracked ice slowly until it seeps through.

EAU
d' WEE-WEE

Here's a golden shower for an-nointing a bride well-made.

Fill a shaker half-full of cracked ice, add 2 fresh eggs, 1 tsp. sugar, juice of 1 lemon, 3 ozs. Eau d'vie.

Shake well! Strain into large rock glass. Then latch onto something weak and willing, do it again, and down the thatch!

PRUNE TANG

Many an old prune got her wrinkles because she stayed dry too long. So here's a little hell raisin' which may help you skin a prude.

1 pint unsweetened prune juice
8 ozs. vodka
½ tsp. cinnamon
½ cup unsweetened pineapple juice
1 tsp. nutmeg

Combine all ingredients, stirring well, and pour into chilled cocktail glasses and hot guests. Top lightly with nutmeg. Don't put the pussy out, but turn down the lights and the sheets.

MOIST DREAMS

Alexander conquered the world. And now so can you!

In this order, fill shaker with ⅓ cracked ice, then add 1 tsps sugar, 1 egg, 2 oz. heavy cream, 2 oz. brandy, 2 oz. light rum, 2 oz. crème de cacao.

Agitate briskly, strain into two cocktail glasses. Serve her as you would be served. And cry, 'Seep, perchance to cream!'

Here's a gamboler's drink any Uncle would love. Especially if the dice were loaded and so were you the night before . . . or before dinner when night comes round, and you want her to.

3 oz. aquavit
2 oz. clam juice
2 oz. tomato juice
1 dash Worcestershire sauce
1 pinch black pepper
juice of $\frac{1}{2}$ lime

Shake a little with equal parts of cracked ice, and strain into 8 oz. glass.

UP-THE-AUNTY

THE SLAMMER

This is for the countdown when you're missile-minded on a long winter's night.

Go out in the hall and beat your chest and grab something pretty to build a dream with. Take her home. Then take 5 oz. Irish booze, 2 oz. water, 1 tsp. cinnamon. Mull with lemon peel (peel half a lemon and cut peel into small bite-sized pieces, add 3 tspns. sugar, and crush with mortar or heavy spoon in giant rock glass or pestle).

Put in metal mug and heat slowly over spirit lamp, or put in small saucepan over low flame, do not boil. Lace with heavy cream, serve her your slammer piping hot.

COW LICK

A brave bull is a cow poker, but a cow's lick is a bull's delight. And this one's for any bull in a bare market. So if the old stock feels like it's ready to rise, here's how to prepare for a jump.

1 cup light cream
1 oz. white crème de menthe
1 oz. crème de cacoa
3 oz. light rum

Fill shaker with crushed ice. Pour in cream and ingredients. Shake briskly. Serve in rock glass, and get in a few licks of your own.

LATE-COMER'S-REST

If you've been down too long, you might need a potent pick-me-up. So after a jag from a hard jog in place, a long side-slip in Marlboro country or if you suffer from a case of rotating push-ups . . . crawl out to the kitchen and rise up singing with this one.

> 1 oz. brandy
> 3 oz. dark rum
> 4 oz. heavy cream
> 1 beaten egg
> 3 tsps. honey

Shake very very well with cracked ice and strain into glass.

PRICKED
PEACH

After you've had your Cock-In-Hand,
here's a perfect follow-up. All you need
is a ripe pink peach ready for pricking,
and a place to lay her while she soaks.

20 oz. stemmed goblet or bowl
2 splits dry champagne
4 ozs. fine brandy
1 large very ripe peach

Peel your peach. Then prick your peach
with the tines of your favourite fork, the
deeper the pricking the better the result.
Lay peach in goblet or bowl and slowly
pour brandy upon it so that it soaks in
completely, let excess remain in bottom.
Fill with champagne until peach is
covered. Drink, enjoy! Eat your peach!
A pricked peach serves two.

UNDER
THE
KILT

This is really a threesome, fit for a lowdown highland fling!
You just take three layers and form a soft sandwich. But be
careful who goes down first.

In tall but very narrow liqueur or pousse cafe glass, pour first
2 oz. Scotch whiskey, then gently pour 2 oz. layer of Drambuie,
then float on 2 oz. cream.

MORNING
CONNECTION

Once you're up, if you ever go down in the morning, here's how to put a little spice in your java jive. Just get your gal down and then the two of you get settled into some happy kitchen nookie and begin to mix it up.

3 cups strong, hot coffee
4 tblsps. chocolate syrup
1½ tsp. cinnamon
½ tsp. nutmeg
2 tblsps. sugar
2 oz. dark rum

Mix chocolate syrup with other ingredients until blended. Pour into hot coffee and stir thoroughly. Add rum, stir again. Serve in mugs for two.

THE 19th HOLE

To the wise golfer who knows that the longest stroke is the fairest way, a swizzle stick is just another shaft to ball with. So take your putter in your hand and stir around your favourite loving cup like this.

4 ozs. dark rum
1 oz. light rum
1½ ozs. *fresh* lime juice, mixed with 2 tsps. sugar
2 ozs. water and ice
2 ozs. unsweetened pineapple juice

Shake well with ice and strain into large glass filled with cracked ice.

A Note on Measures

The measures given in the text are American. A guide to comparative British equivalents is given below.

1 American pint = 16 fluid ozs.
1 English pint = 20 fluid ozs.
1 American cup measure = 8 fluid ozs.
1 American tablespoon = 3 flat teaspoons.
All American spoon measures are a flat spoonful.

	Weight of 1 American cup	Weight of 1 American tablespoon
Flour	4½ ozs.	½ oz.
Sugar	7 ozs.	¾ oz.
Butter	7 ozs.	¾ oz.